i LOVE You

© 2007 White Star S.p.A.
Via Candido Sassone, 22/24
13100 Vercelli, Italy
www.whitestar.it

TRANSLATION: ANGELA ARNONE

ISBN 978-88-544-0335-2

REPRINTS:
1 2 3 4 5 6 11 10 09 08 07

Color separation: Chiaroscuro, Turin
Printed in China

i
Love
you

EDIZIONI WHITE STAR

Your best photo

Day Month Year

edited by Valeria Manferto De Fabianis

graphic design by Clara Zanotti

To my Valentine

Famous Kisses

Hearts of All Sorts

Cartoons in Love

To my...

...VALENTINE

♥

IT'S LIKE SPRING.

You smell the scent in flower petals,
you feel your heart beat in the air.

(designed in 1910 c

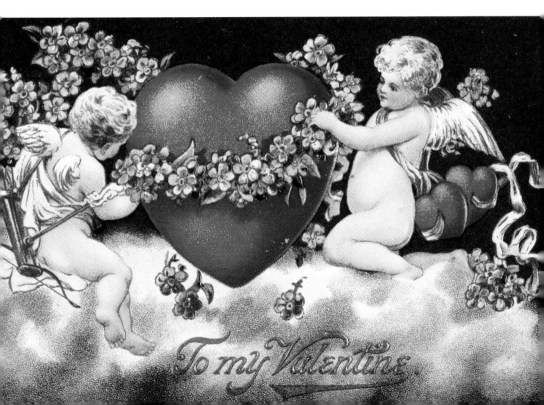

To my Valentine.

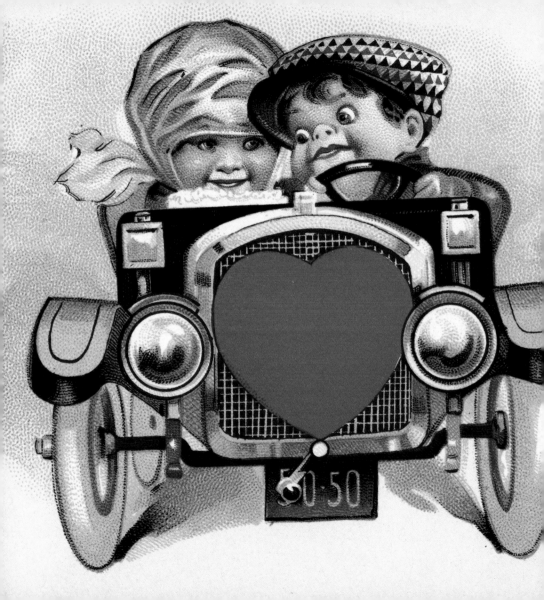

If
you will be
my
Valentine
- I will
gladly share
my heart
with thine. .

Come away,
away with me,
come into
this love,
don't ever
get lost . . .

– Paolo Conte

(designed in 1905)

"Love
does
not eat
doves . . ."

– *William Shakespeare*

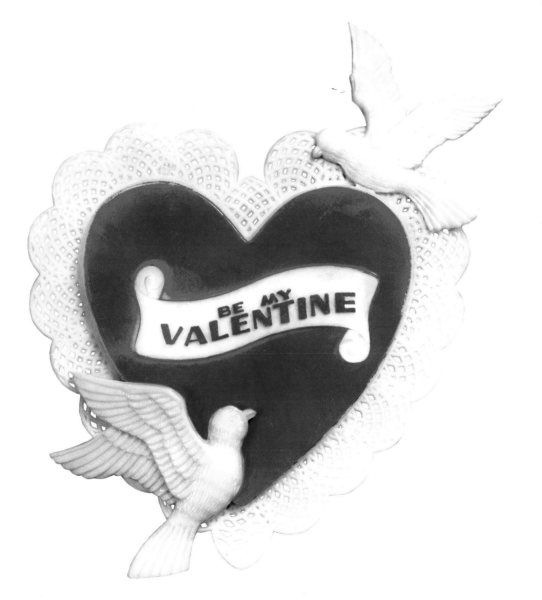

I wait
like
a lobster.
Will you
have
pity and
marry me?

WHO,
BEING
POOR,
IS LOVED ?

– Oscar Wilde

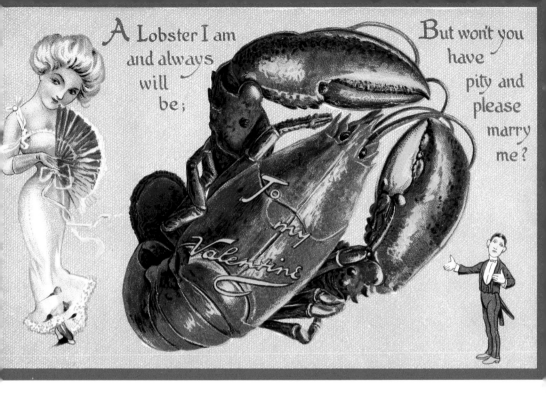

(designed in 1907)

(designed in 1906)

I'm waiting for you.
Is my heart big
enough for you?

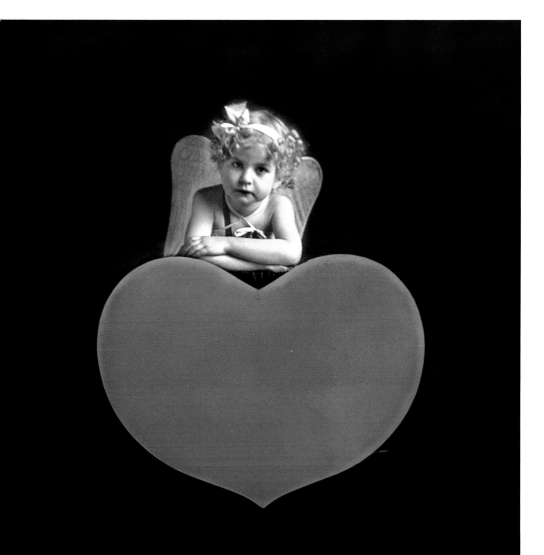

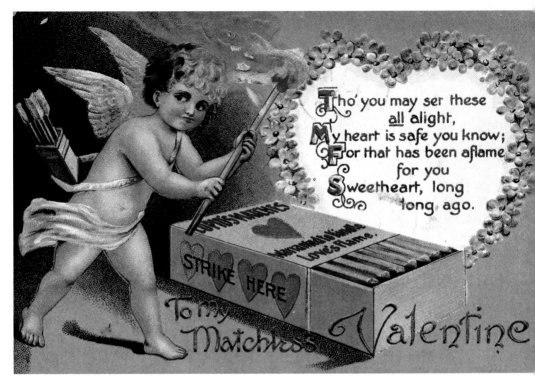

Tho' you may ser these <u>all</u> alight,
My heart is safe you know;
For that has been aflame for you
Sweetheart, long long ago.

STRIKE HERE

To my Matchless Valentine

(designed in 1910)

(designed in 190

Love is fire. But you don't know
if it will warm you heart or burn down your house.

– Joan Crawford

LOVE
MATCHES
TO MY VALENTINE!

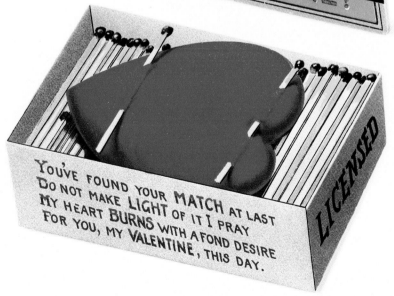

YOU'VE FOUND YOUR MATCH AT LAST
DO NOT MAKE LIGHT OF IT I PRAY
MY HEART BURNS WITH A FOND DESIRE
FOR YOU, MY VALENTINE, THIS DAY.

LICENSED

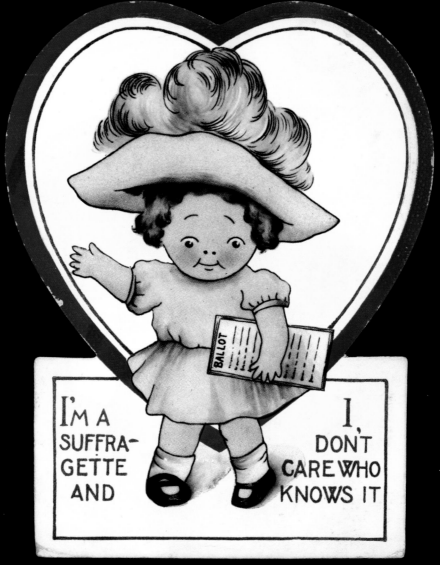

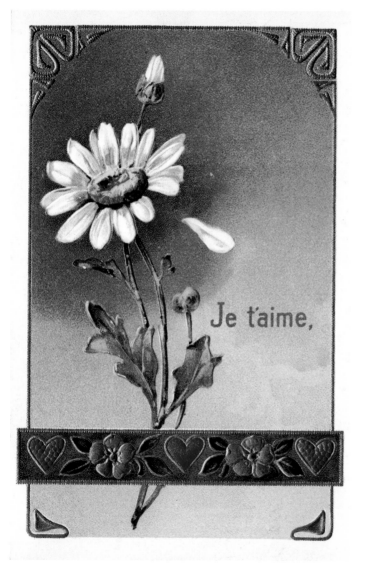

Je t'aime,

"Loves me, loves me not"

(designed in 1906)

beaucoup.

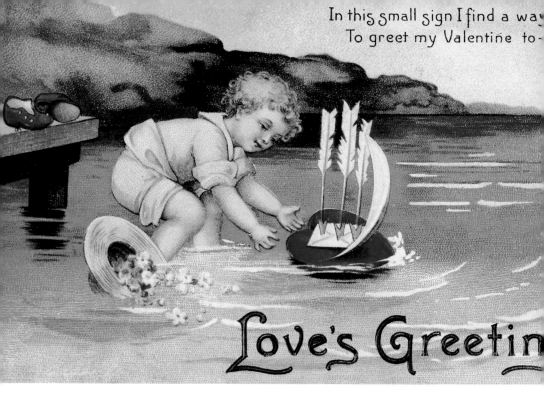

In this small sign I find a way
To greet my Valentine to-

Love's Greetin

Ellen H. Clapsaddle (designed in 1911)

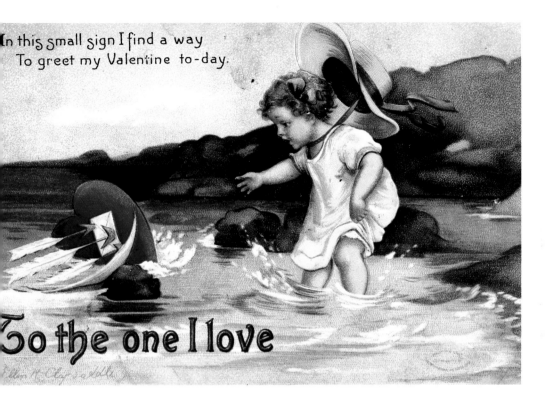

In this small sign I find a way
 To greet my Valentine to-day.

To the one I love

Ellen H. Clapsaddle (designed in 1910)

"LOVE is not weighed in tears."

– Denis De Rougemont

(designed in 1911)

Love is the ability to discover

the similar in the dissimilar.

– Theodor Adorno

(designed in 1908)

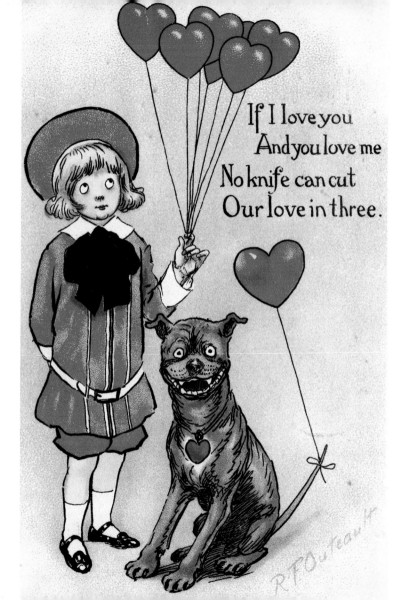

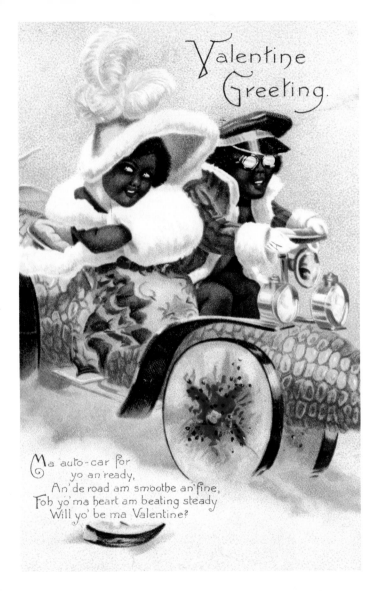

designed in 1904

designed in 1910)

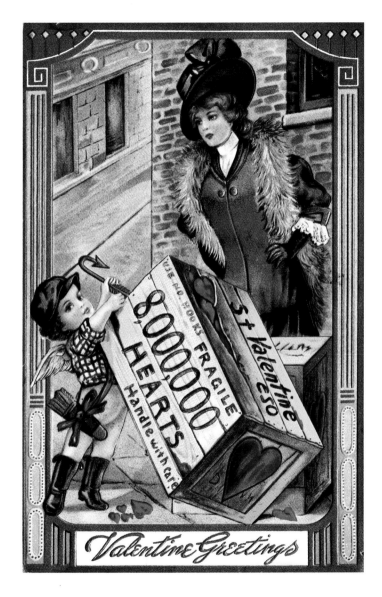

(designed in 1915)

In the game of love
each heart is a targe

VALENTINE PARTY

To my Sweetheart

I'd jump for joy,
sweet Valentine,
If you would say
you would be mine.

Ernest Nister London.
Printed in Bavaria.
N°890.

E.P. Dutton & C°. New York.

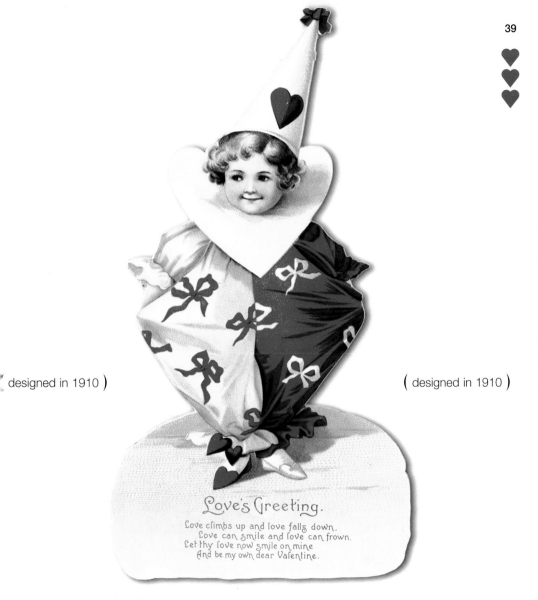

(designed in 1910)

(designed in 1910)

Love's Greeting.

Love climbs up and love falls down.
Love can smile and love can frown.
Let thy love now smile on mine
And be my own dear Valentine.

Famous

KISSES

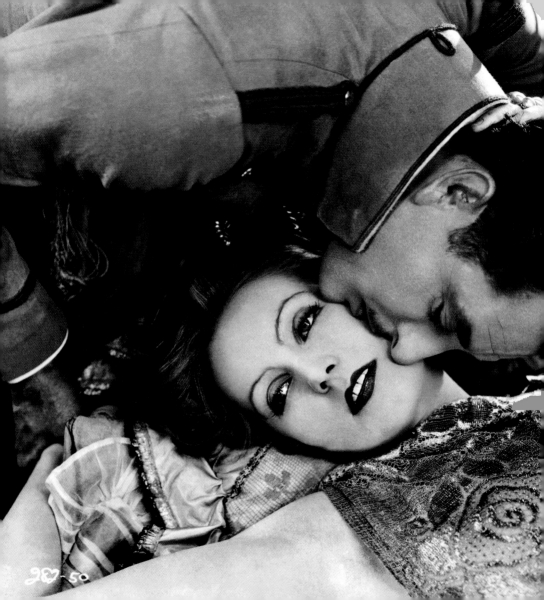

"A kiss before
parting.
Nothing can
separate us."

Greta Garbo and John Gilbert

(from the film *Flesh and the Devil*, 1926)

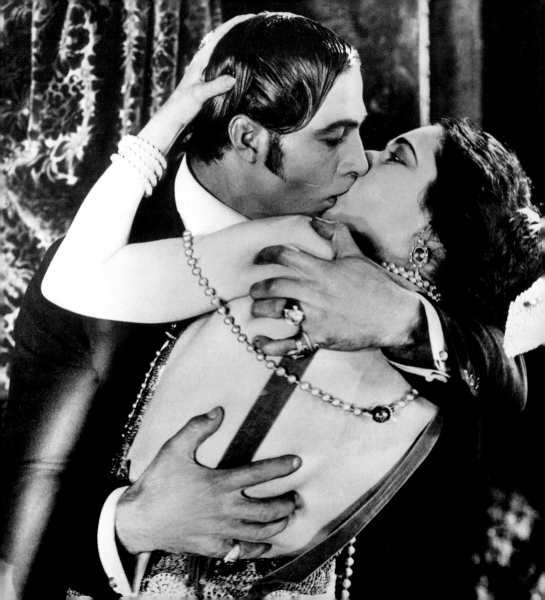

♥

Rodolfo Valentino and Nita Naldi (from the film *Blood and Sand*, 1922)

George K. Arthur and Gertrude Olmstead (from the film *The Boob*, 1926)

Pola Negri and Wallace MacDonald (from the film *The Charmer*, 1925)

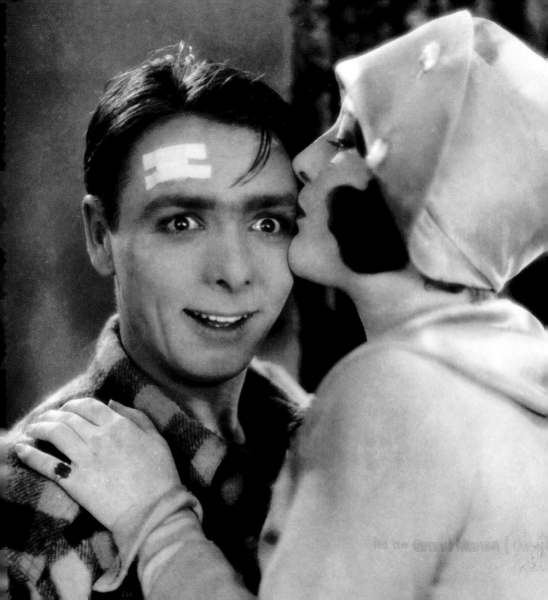

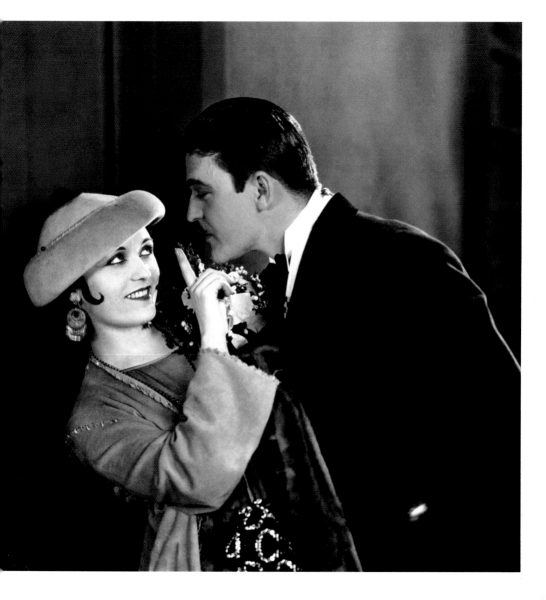

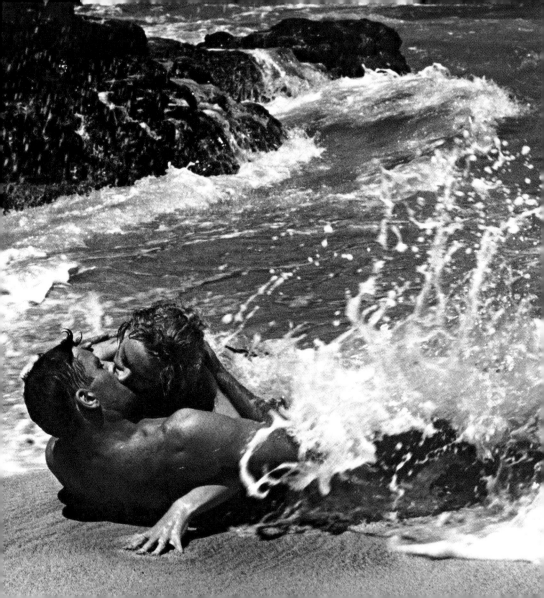

Waves of passion

♥

Burt Lancaster and Deborah Kerr (from the film *From Here To Eternity*, 1953)

Cary Grant and Ingrid Bergman

(from the film *Notorious*, 1946)

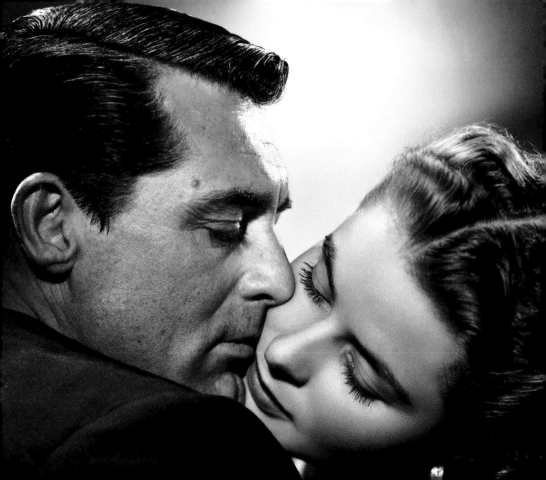

HOUSES
BURN,
PEOPLE
DIE,
BUT
TRUE
LOVE
IS
FOREVER.

Clark Gable and Vivien Leigh
(from the film *Gone with the Wind*, 1939

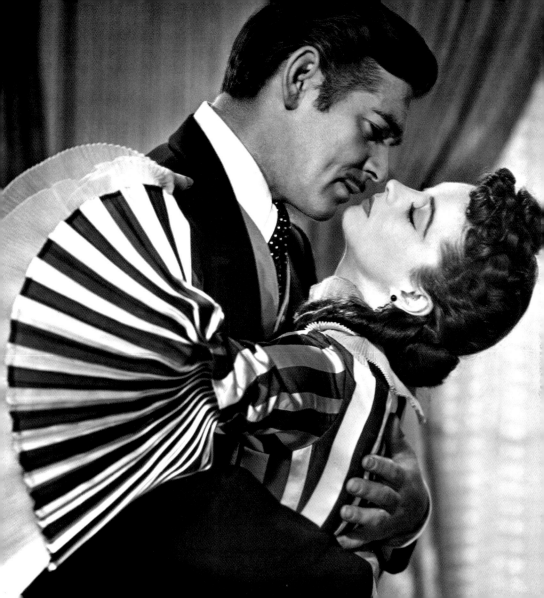

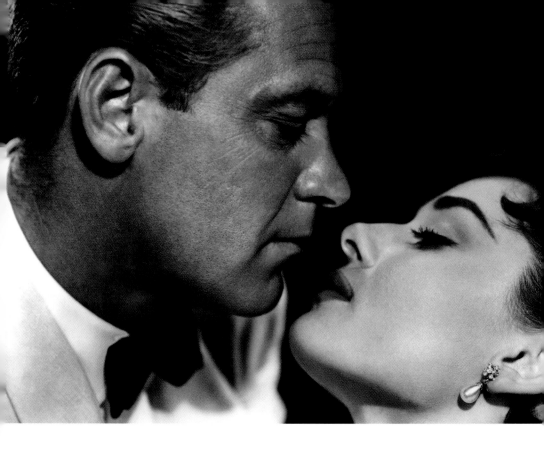

William Holden and Audrey Hepburn

(from the film *Sabrina*, 1954)

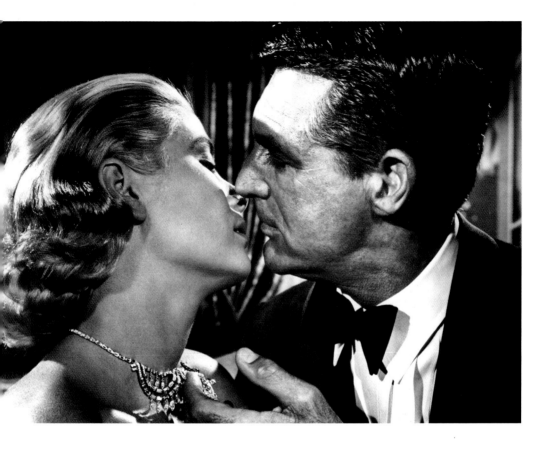

Grace Kelly and Cary Grant

(from the film *To Catch a Thief*, 1955)

"I'll never let anyone
put me in a cage."

"I don't want
to put you in a cage,
I wanna love you."

George Peppard and Audrey Hepburn

(from the film *Breakfast at Tiffany's*, 1961)

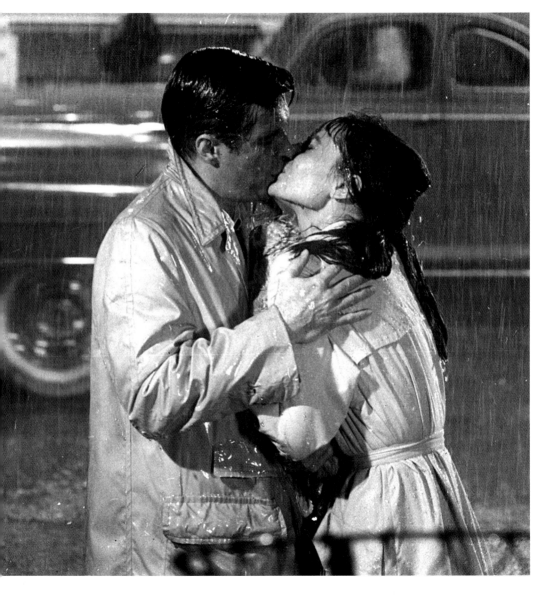

Joanne Woodward and Paul Newman (from the film *The Long Hot Summer*, 1958)

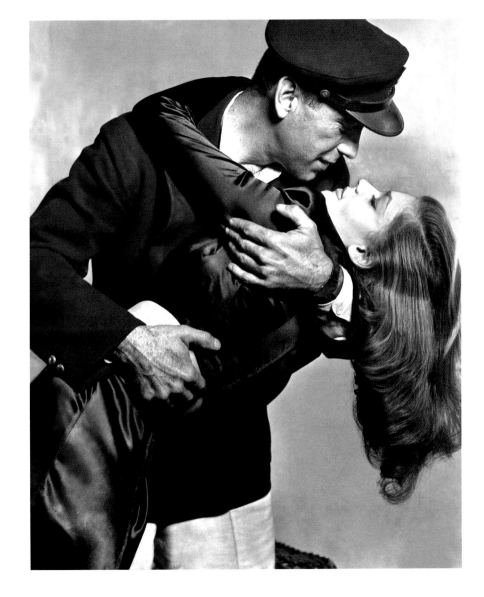

Humphrey Bogart and Lauren Bacall (from the film *To Have and Have Not*, 1944)

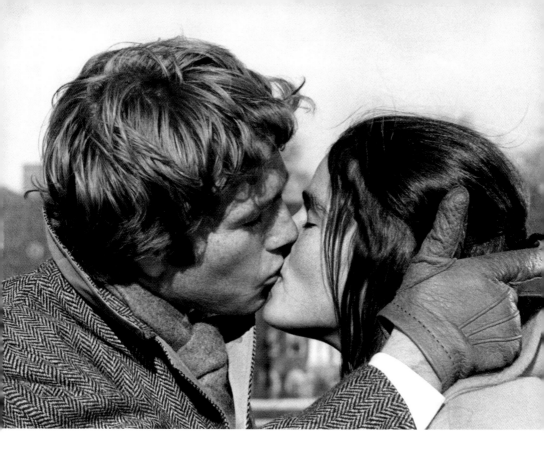

Ryan O'Neal and Ali MacGraw

(from the film *Love Story*, 1970)

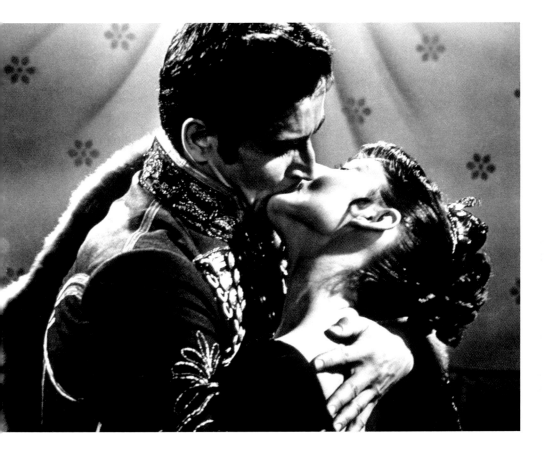

Vittorio Gassman and Audrey Hepburn

(from the film *War and Peace*, 1956)

"LOVE
IS A
DREAM.
SOMETIMES
THE
DREAM
IS MORE
REAL
THAN
REALITY."

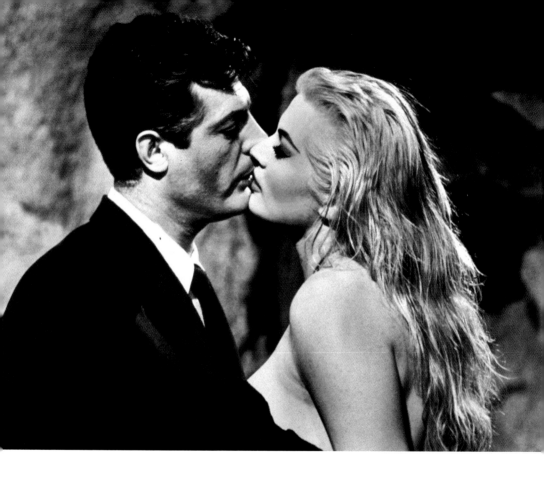

Marcello Mastroianni and Anita Ekberg

(from the film *La dolce vita*, 1960)

"Forget me not,
Anthony."
"Forget you?
I will never go
far enough away
to forget you."

Elizabeth Taylor and Richard Burton

(from the film *Cleopatra*, 1963)

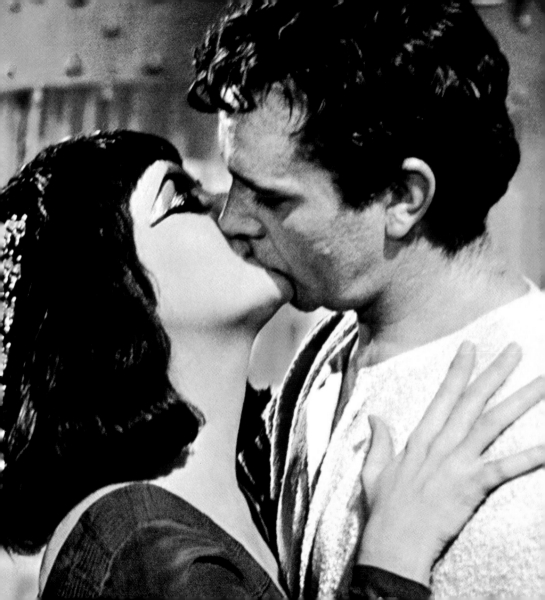

Sandy,
one
day,
who
knows
how,
maybe
our
worlds
will be
one.

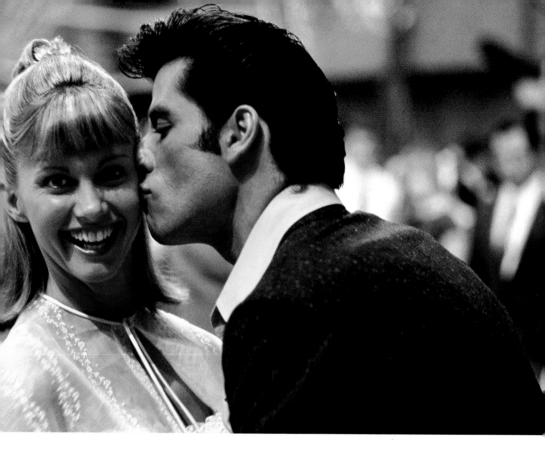

Olivia Newton John and John Travolta

(from the film *Grease*, 1978)

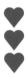

Tobey Maguire and Kirsten Dunst

(from the film *Spiderman*, 2002)

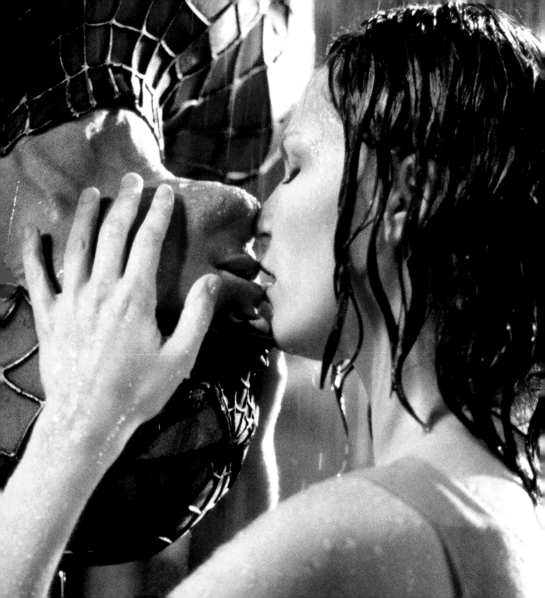

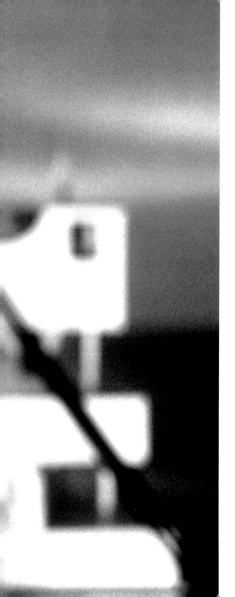

He saved me,
in all the ways
a woman can
be saved.

"**Where shall
I take you,
Rose?**"
"To a star."

Leonardo DiCaprio and Kate Winslet

(from the film *Titanic*, 1997)

Do you think,
once we've dried off
and spent a bit of time
together, that you might
agree not to be my wife?
Do you think the idea
of not marrying me is
something you might
consider?
I mean for the rest of
your life ...

Hugh Grant and Andie MacDowell

(from the film *Four Weddings and a Funeral*, 1994)

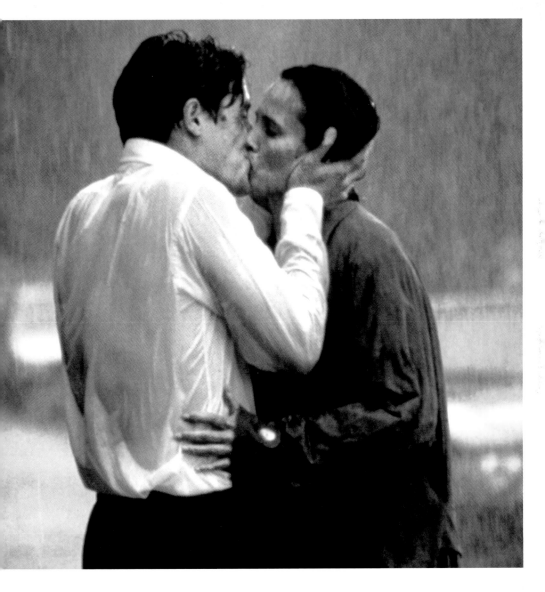

♥

"The love you have inside is beautiful. Carry it with you always."

Patrick Swayze and Demi Moore

(from the film *Ghost*, 1990)

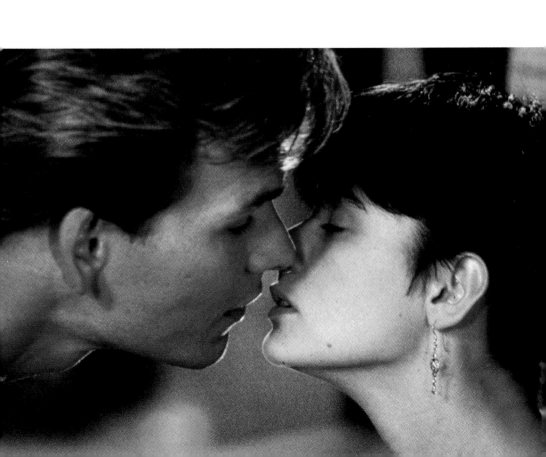

Sharon Stone and Michael Douglas

(from the film *Basic Instinct*, 1992)

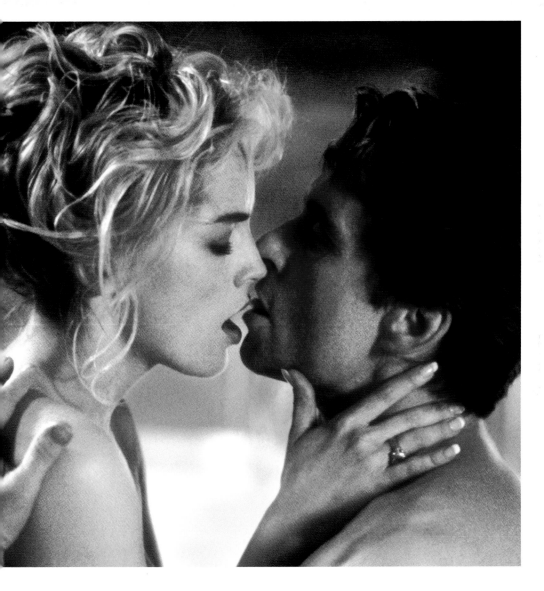

Hearts of

ALL SORTS

"I was
spellbound
by the rhyme
'love ... dove,'
the oldest,
most difficult
in the world."

– *Umberto Saba*

"They die slow death,
those who avoid passion, who prefer
black on white and dotted 'i's,

rather than that tumult of emotions
that make the heart beat ..."

– *Pablo Neruda*

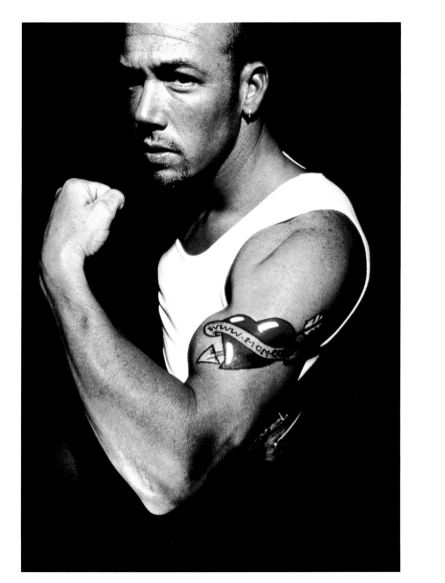

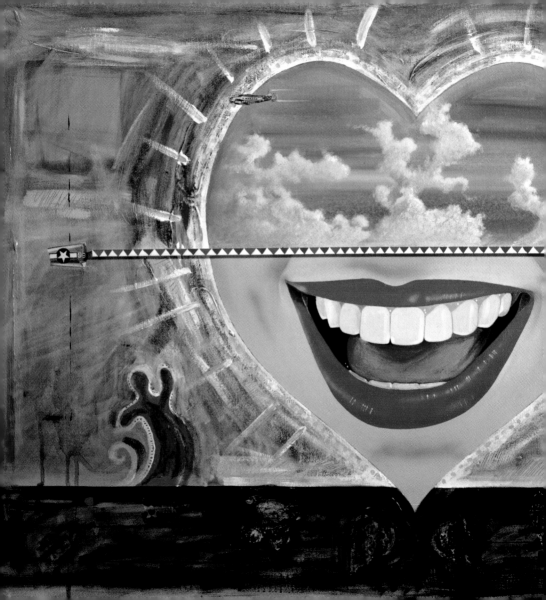

Love lights
a smile
in the heart
of the world.

"SO LEND
ME YOUR ♥
HEART,
IN THIS
GRIDLOCK
OF LIFE
AND LOVE."

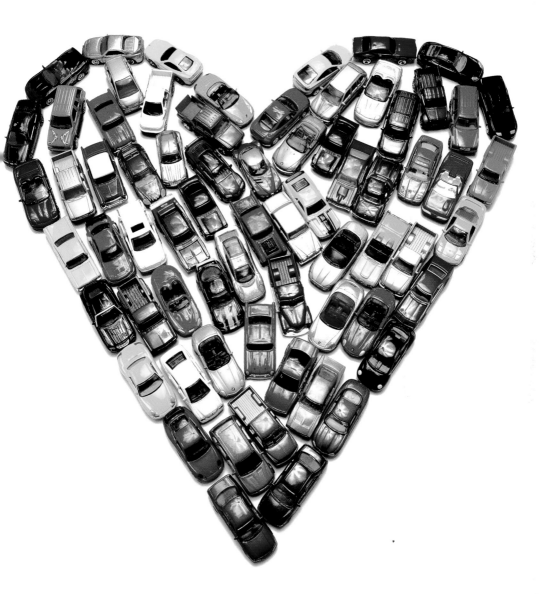

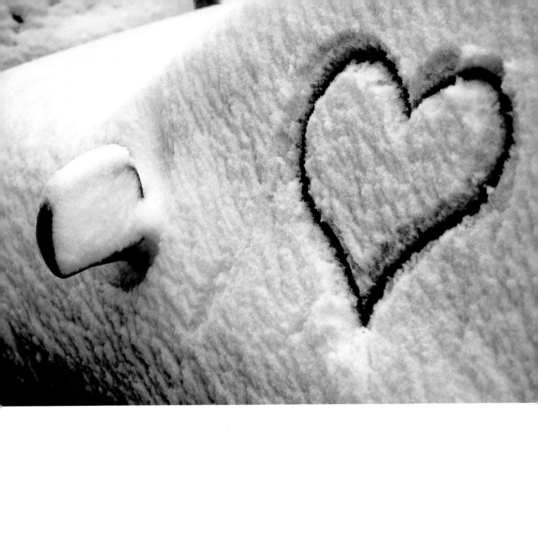

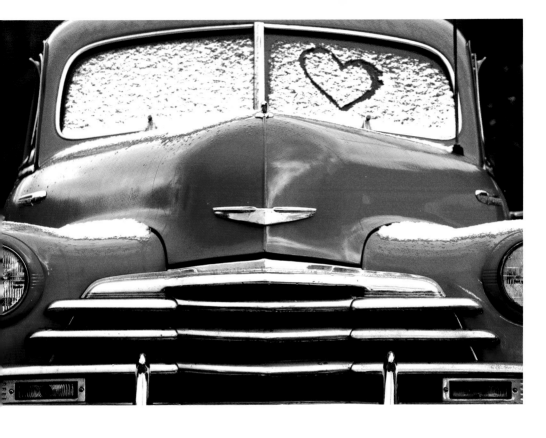

"... and they loved, suspended on a snowy thread."

– Maxence Fermine

Lips to lips heart to heart ...

– Adriano Celentano

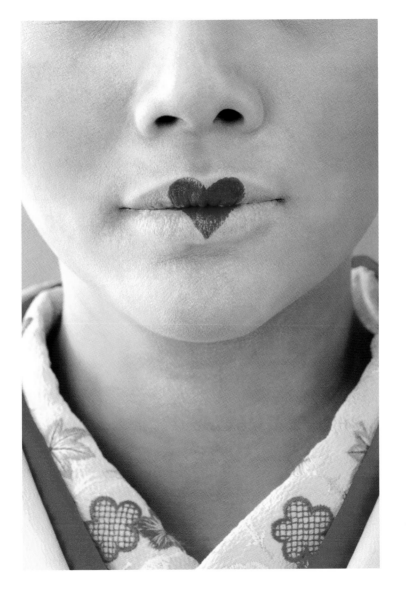

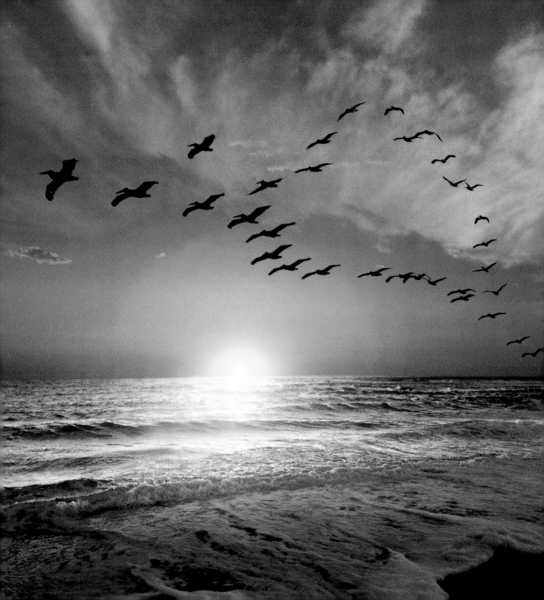

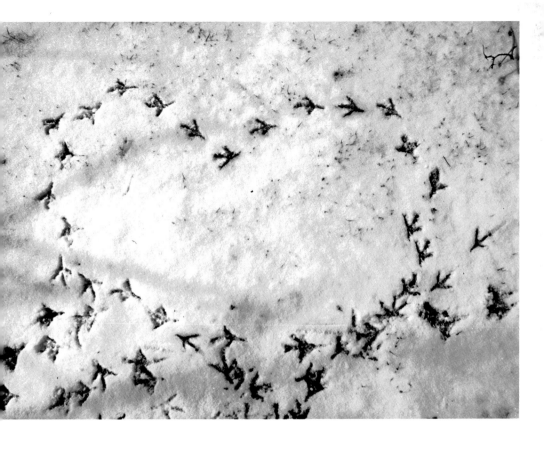

In Heaven or on Earth,
but with the eyes of the heart ...

In the lives of men and women,
there is a season for love as there is a season
for fishing and one for drying out the nets.

Grand Manan (Canad

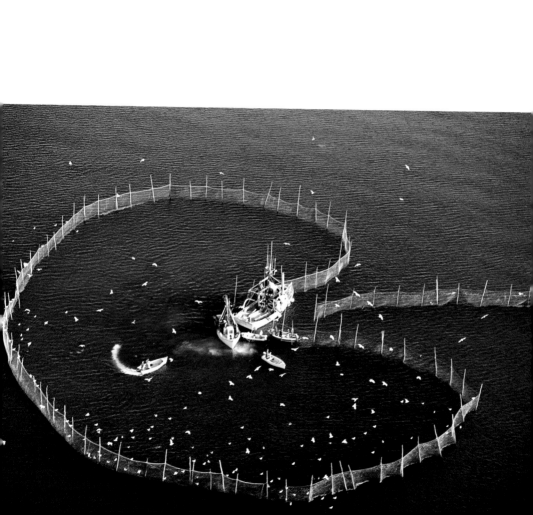

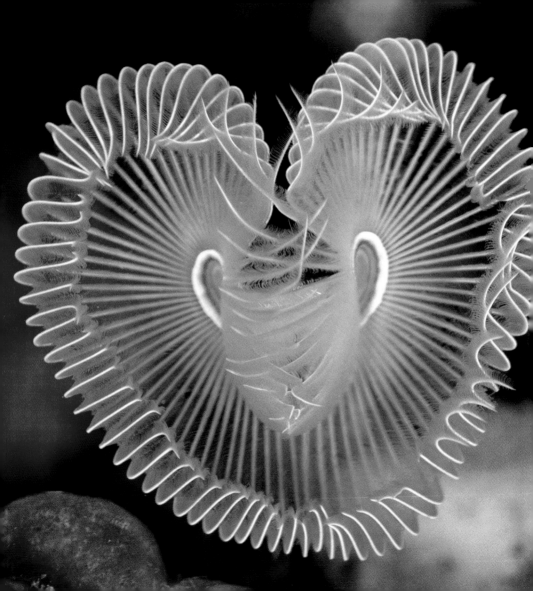

♥

Feather Duster Worm (SABELLASTARTE SP.)

Love spirals

"It was a door with
a spy hole in it.
I looked and love
was knocking."

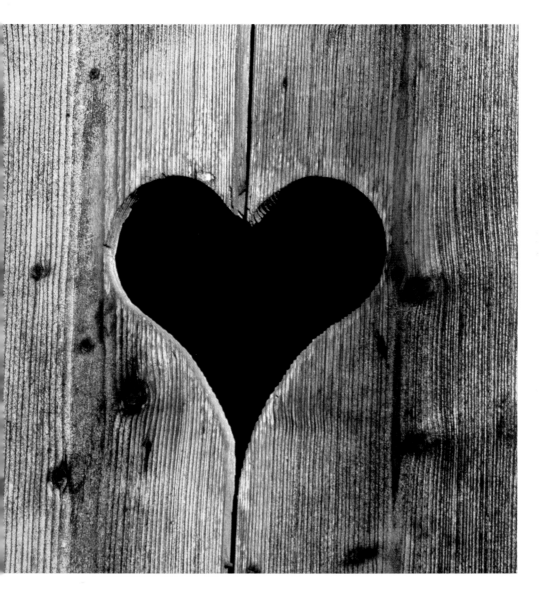

"A spiral of love with a heart at the center."

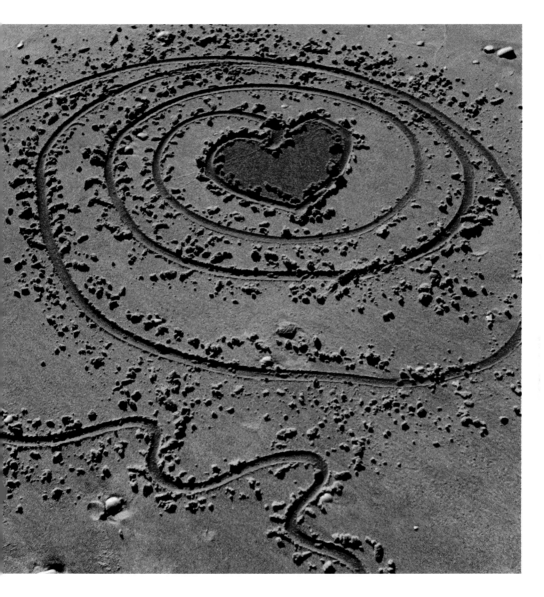

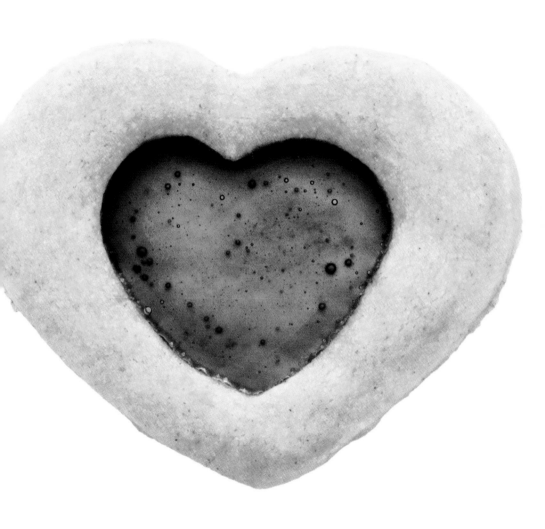

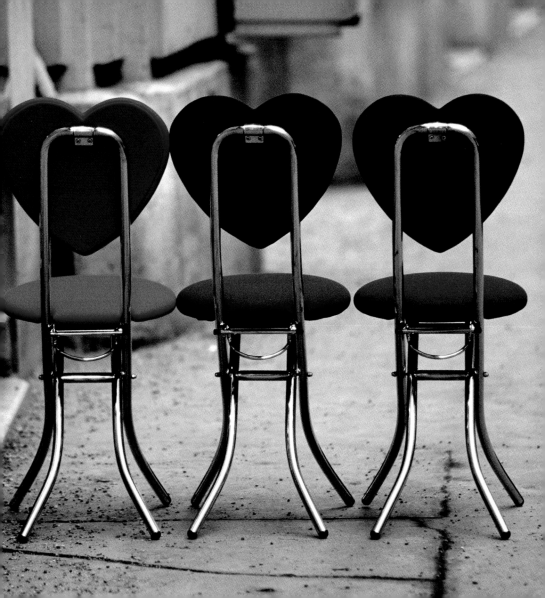

♥

"Love is a bar open all hours . . ."

– *Grazia Varesani*

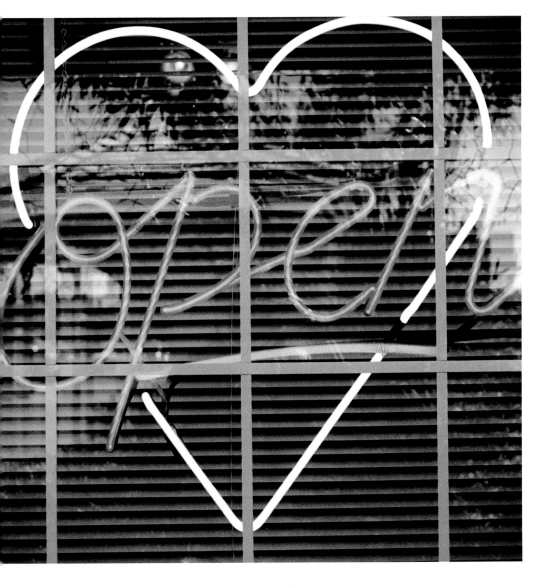

What better

action than

the bold and

reckless

closing of

a locket

promising

love?

– Federico Moccia

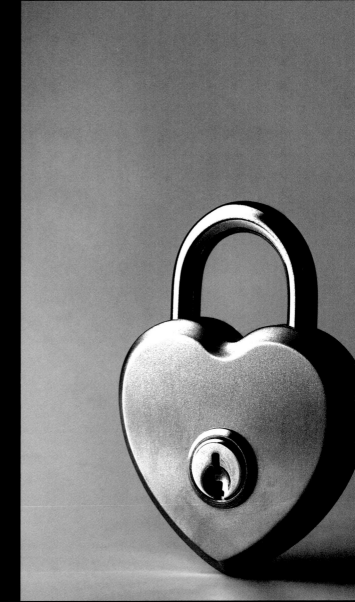

 **... sometimes it doesn't take much to realize
that the door was never locked.**

– Federico Moccia

Cartoons

IN LOVE

I love you

"A kiss, to start another dream."

Sleeping Beauty (Walt Disney, 1959)

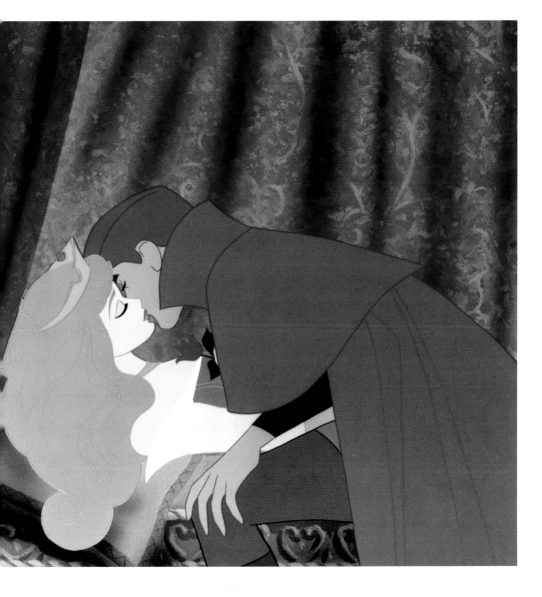

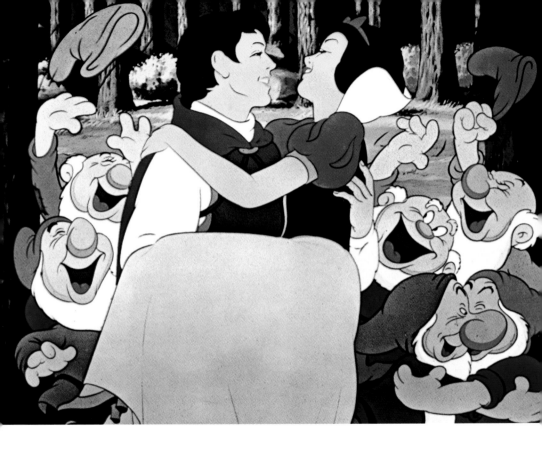

Snow White and the Seven Dwarfs

(Walt Disney, 1937)

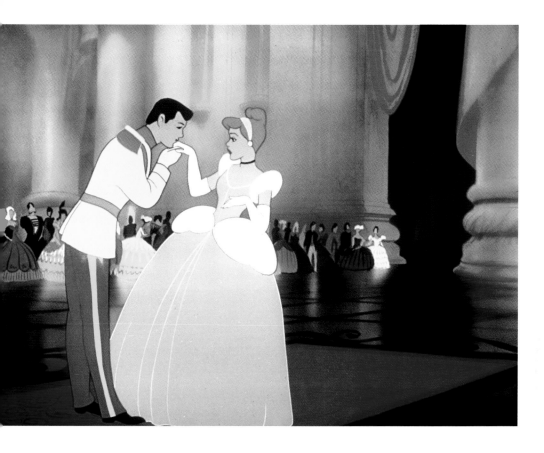

Cinderella

(Walt Disney, 1950)

Who Framed Roger Rabbit?

(Walt Disney-Amblin Entertainment, 1988)

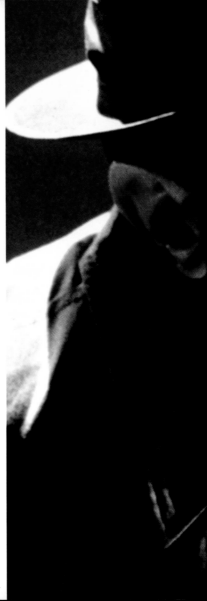

"Happiness?
A big family!"

101 Dalmatians (Walt Disney, 1961)

Aladdin (Walt Disney, 1992)

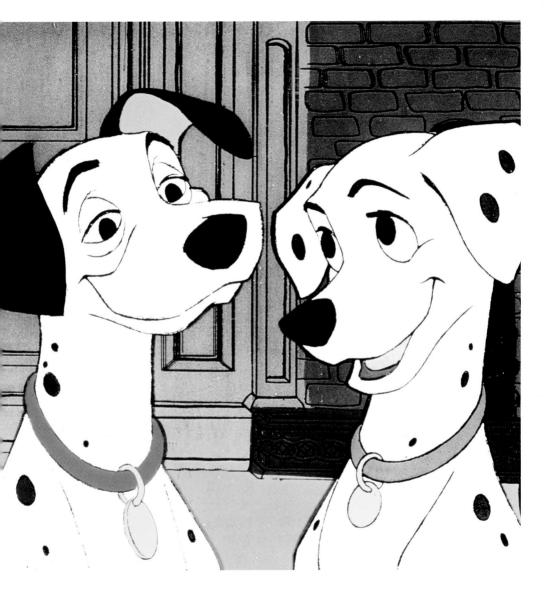

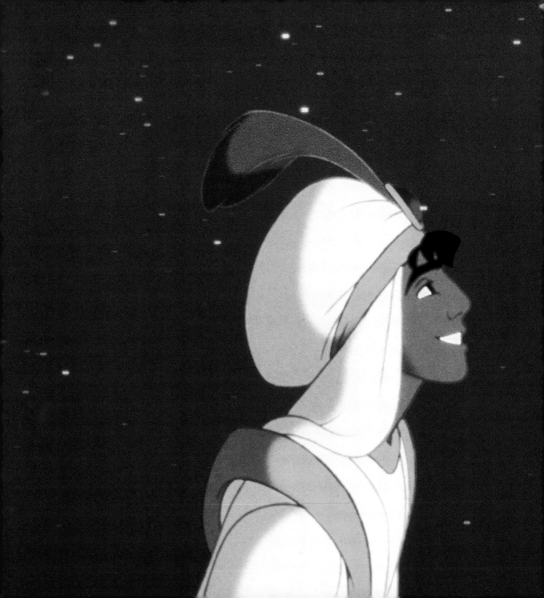

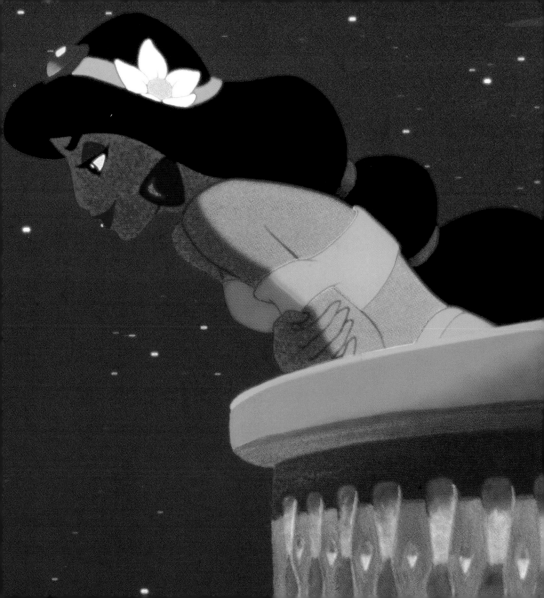

Donald and Daisy

(from *Donald's Failed Fourth*, Walt Disney, 1999)

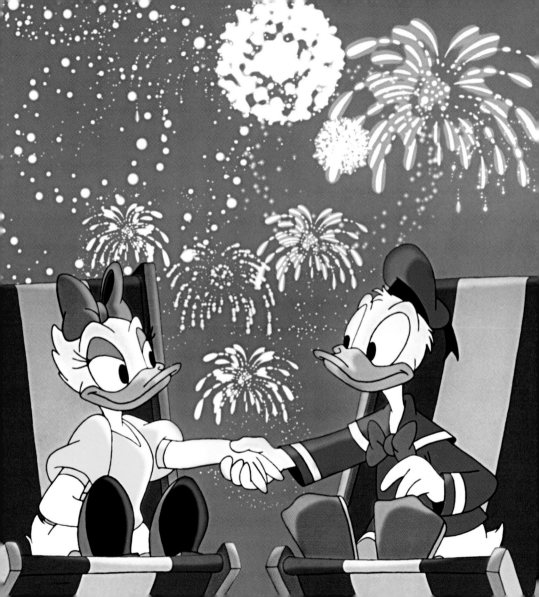

"Yeah,
Minnie's the one we're waitin' for ...
Put a grin on your chin 'cause Minnie is in!"

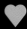

– From the song "Minnie Mouse in the House" (Walt Disney)

Minnie and Mickey (from *Micky Mouse Works*, Walt Disney, 1999)

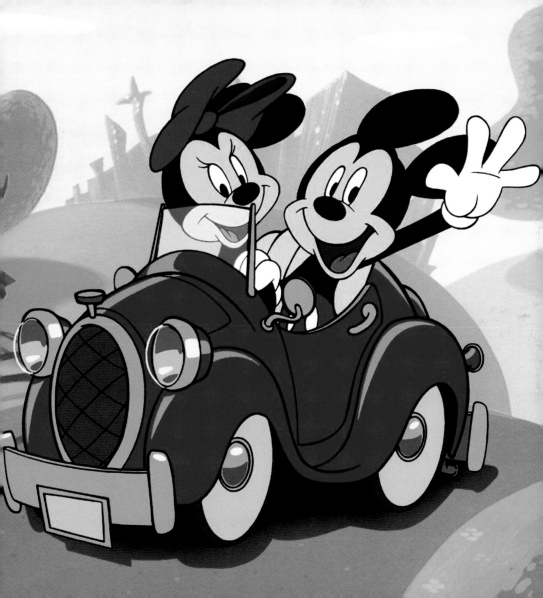

Kimba the White Lion (Osamu Tezuka-Mushi Productions, 1997)

Lady and the Tramp (Walt Disney, 1955)

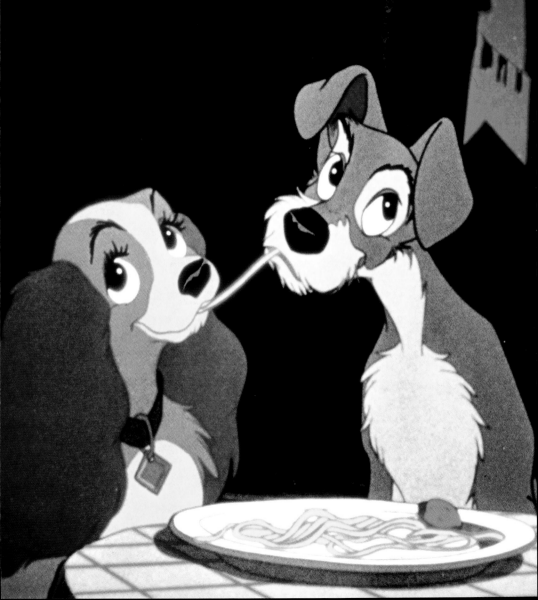

"Once we
watched a lazy
world go by.
Now the days
seem to fly.
Life is brief,
but when it's
gone love goes
on and on."

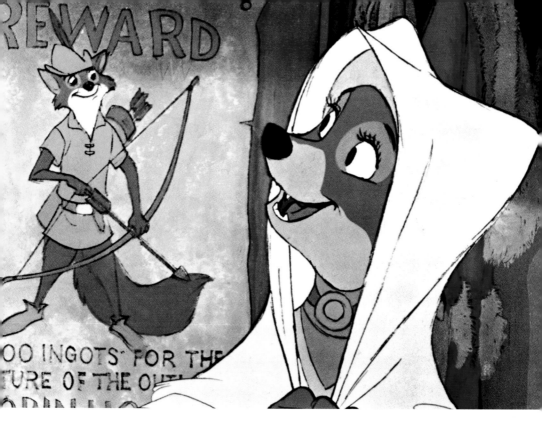

Robin Hood (Walt Disney, 1973)

The Aristocats (Walt Disney, 1970)

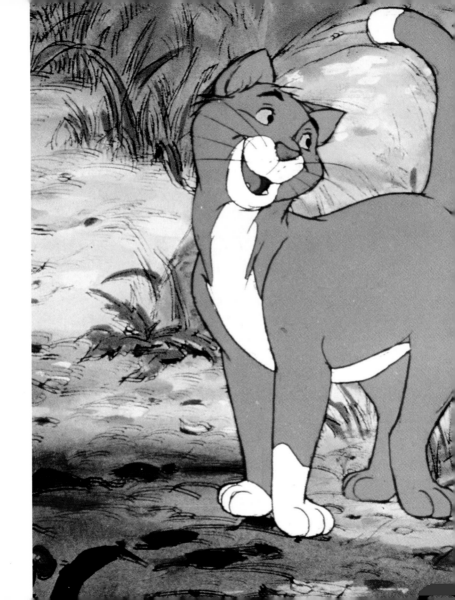

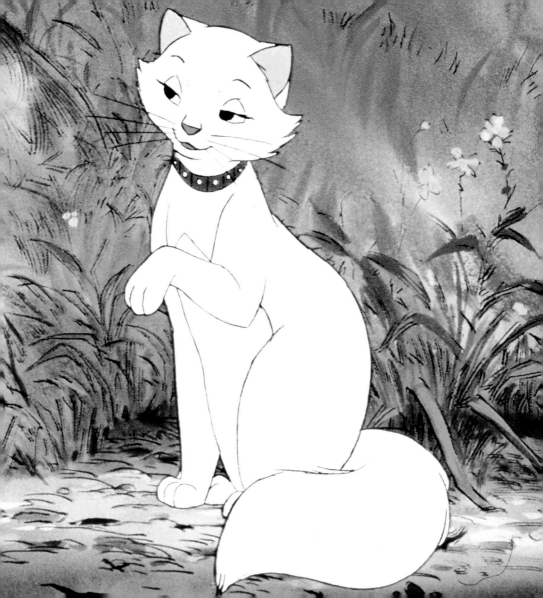

**"Our love
is like a
red red rose
with quite a
long thorn!"**

The Mask

(Dark Horse Entertainment-
New Line Cinema, 1994)

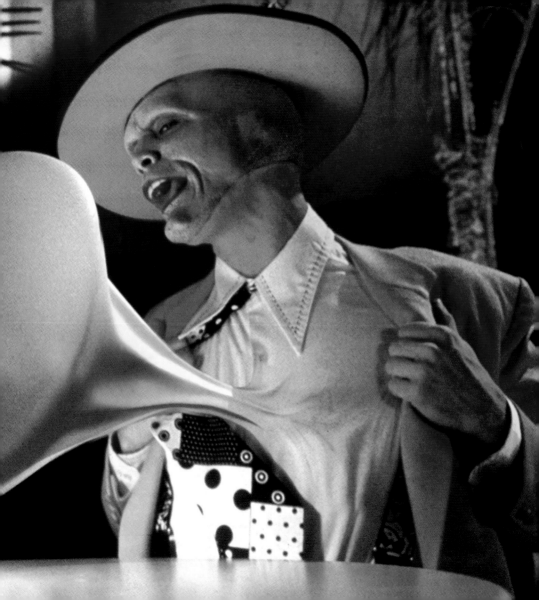

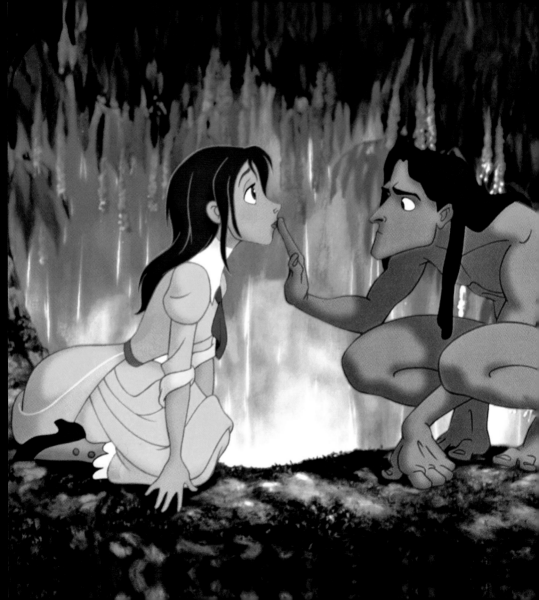

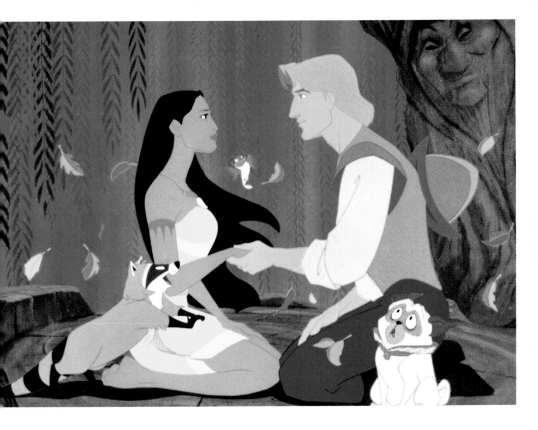

Pocahontas (Walt Disney, 1995)

Tarzan (Walt Disney, 1999)

Asterix and Caesar's Gift

(Éditions Dargaud-Eagle Pictures, 1984)

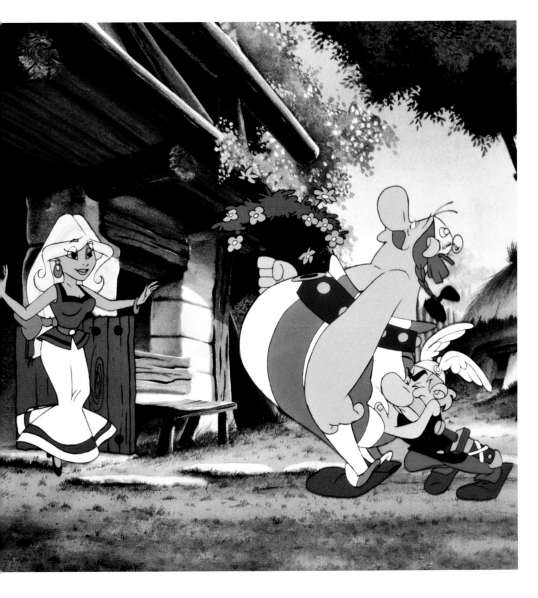

"You're so beautiful that the beast that will fall asleep every time you smile at it."

Beauty and the Beast (Walt Disney, 1991

Shrek 2 (DreamWorks Animation, 2004

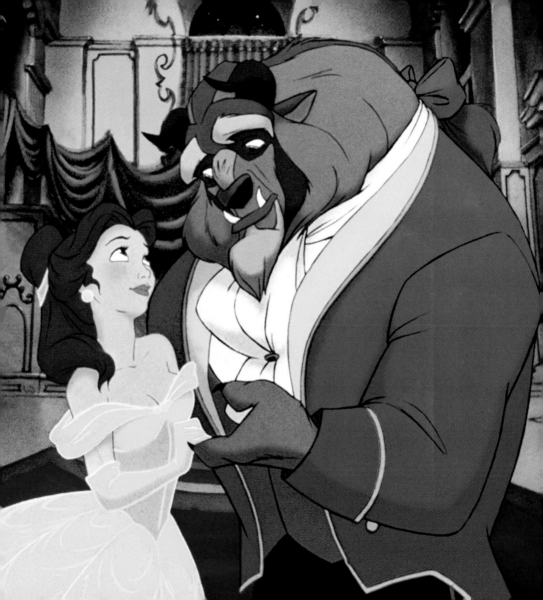

photo credits